CLUES TO AMERICAN SCULPTURE

CLUES
to
American
Sculpture

Kathleen Sinclair Wood
Illustrated by Margo Pautler Klass

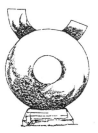

·STARRHILL PRESS
Washington & Philadelphia

Dedicated to
Emily Taggart Sinclair and Arthur Joseph Pautler
for their inspiration

Published by Starrhill Press, Inc.
P.O. Box 32342
Washington, DC 20007
(202) 686-6703

Library of Congress Cataloging in Publication Data

Wood, Kathleen Sinclair, 1941–
 Clues to American sculpture/by Kathleen Sinclair Wood;
illustrated by Margo Pautler Klass.
 p. cm.
 Includes bibliographical references.
 ISBN 0-913515-43-4: $7.95
 1. Sculpture, American. I. Klass, Margo Pautler. II. Title.
NB205.W6 1990
730'.973—dc20
 90–30580
 CIP

The illustrations for this book are original
drawings of the sculptures in pen and ink. The drawings
are based on the works of art and, except for those of sculptures
in the public domain, were done with permission of the artist,
the institution of ownership or a licensing rights society.

The author and illustrator would like to acknowledge
the generous assistance of the artists, museums and private
collectors represented in this book. They express special gratitude
to Anita Duquette, Manager, Rights and Reproductions, Whitney
Museum of American Art, New York, and to the Rights and Reproductions
Department, Walker Art Center, Minneapolis.

Printed in the United States of America

First edition

1 3 5 7 6 4 2

CONTENTS

This guide traces the development of American sculpture from its inception in the utilitarian folk tradition through its attempts to identify itself with the great Western Classical tradition to the fertile period of the 20th century. Throughout we emphasize those characteristics that are specifically American. Without downplaying European influence, we note the differences that occur when American patrons and sculptors emphasize their own values as distinct from European values.

Of necessity, we have limited our definition of American sculpture to the context of Western art. We regret lacking the space to develop native and folk sculpture, both of which have rich traditions.

The fundamental American theme in sculpture is the insistence on realism. During the 19th century, when idealism was the dominant European mode of artistic expression, Americans tempered the ideal with the real. During the 20th century, American sculpture has flirted with European abstraction but has always returned to its first love—the recognizable object.

American sculpture tends to be inclusive rather than exclusive, a reflection of the democratic ideal. Many American artists of the 20th century are immigrants, bringing different ideologies and techniques to their adopted culture's sculptural tradition, and broadening and enriching it in the process.

Since the end of World War II, sculpture has moved to the forefront of creative activity in the United States. Sculptors are using new materials and techniques to explore and expand the boundaries of art. They are breaking down the barriers that traditionally have separated sculpture from painting, architecture and landscape architecture. As we approach the close of the 20th century, American sculpture has come of age.

We hope *Clues to American Sculpture* will accompany you as you visit galleries, museums and sculpture gardens and as you explore city centers seeking out the old and the new sculptural expressions.

Kathleen Sinclair Wood
Margo Pautler Klass

Augustus Saint-Gaudens' *Diana* is a quintessential piece of American sculpture. It looks back to sculpture's beginnings in the folk tradition, and it looks forward to the most significant developments of the 20th century.

Diana was designed to be a weather vane, hearkening back to America's earliest sculptors, the artisans who carved utilitarian objects. *Diana* relates directly to Classical antecedents, which have exerted such a profound impact upon art in this nation. In anticipation of 20th-century developments, *Diana* is an open sculpture, incorporating space as an essential ingredient; the composition consists of solids and voids and their relationships, constantly in flux. And, finally, *Diana* was designed to move in the wind, to be seen from all sides and angles,

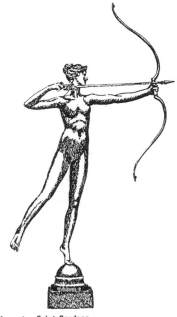

Augustus Saint-Gaudens
Diana, 1893–94 (this cast 1928)
Gilded-bronze reduction, h. 102"
The Metropolitan Museum of Art, New York

each view revealing a different facet. In this respect, she is a kinetic sculpture, predicting a whole movement in the 20th century.

Until the 20th century, sculpture was conceived of as a solid mass displacing space. Saint-Gaudens opened up that mass, incorporating voids within it as an integral part of the overall composition. These voids, as defined and framed by the solids, change as the sculpture moves, revealing different perspectives in the same way as does a 20th-century wind-driven Alexander Calder mobile or a motorized José de Rivera sculpture. Balancing on her toe, *Diana* foreshadows Calder's steel stabiles, defying the laws of gravity.

With *Diana,* Saint-Gaudens managed at once to pay tribute to the origins of American sculpture and to foreshadow the concepts and techniques that have made sculpture such a vital part of late 20th-century culture.

Gravestones were the first American sculptures. They were carved by craftsmen who did not consider themselves artists and were not expected by their employers to have any artistic vision. These stones, with simple rosettes or radiating suns, stood implacably for the strictly utilitarian spirit of the colonists.

In the 17th-century England that the settlers left, patronage for artists and architects came primarily from the monarch and the court. Thus, the colonists arrived in the New World free of artistic traditions. The first colonial architecture consisted of practical buildings erected solely for protection from the weather. The first colonial paintings were advertisements for businesses and emblems on coaches.

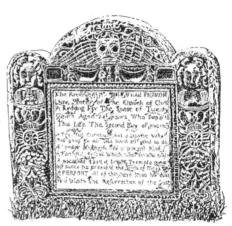

Weather vanes, advertising signs and ships' figureheads can be considered with tombstones as early sculptural efforts. As the colonists prospered and workers gained more skill in their trades, these woodcarvers, carpenters, joiners and stone carvers began to increase their stock of images. Stone carvers chiseled figures of

Gravestone of the Reverend Jonathon Pierpont
(d. 1709)
Initialed "N.L." (Nathaniel Lamson?)
Slate, h. 27½"
Wakefield, Mass.

LOOK FOR:

Functional forms (weather vanes, advertising signs, figureheads, gravestones)
Primitive workmanship
Painted surfaces

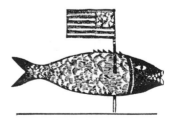

Fish with Flag Sign, c. 1850
Painted wood and iron, w. 60½"
Shelburne Museum, Shelburne, Vt.

death and rebirth, including the winged skull, on their gray slabs.

To the end of the 17th century, American stone sculpture remained flat relief carving. One of the earliest American sculptural portraits is the two-dimensional representation on Reverend Jonathon Pierpont's Gravestone.

Of all the early sculptors, the ship carvers were the most proficient. The figureheads on American ships proclaimed their makers' skills around the world. The Skillins' workshop in Boston produced some of the most elaborate work. Run by Simeon Skillin Sr. (1716–1778) and his sons, the shop produced ornamental carving for furniture, gardens and architecture, in addition to the renowned ships' figureheads. In 1767, the Skillins created the earliest recorded American portrait bust, *William Pitt.*

Little Navigator, c. 1810
Attributed to Samuel King
Painted wood, h. 25¾"
New Bedford Whaling Museum, New Bedford, Mass.

Gravestone of Polly Coombes (d. 1795)
Slate
Bellingham, Mass.

Weathervane; Saint Tammany, mid-19th century
Molded and painted copper, h. 108"
Collection, Museum of American Folk Art, New York

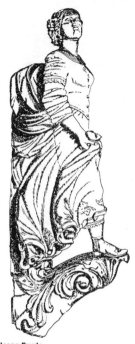

Isaac Fowle
Lady with a Scarf, c. 1820
Wood, h. 74"
The Bostonian Society, Old State House,
Boston

The Skillin sons, John (1746–1800) and Simeon Jr. (1756/57–1806), attempted some high style art in addition to the utilitarian objects produced in their Boston woodworking shop. Their *Mercury,* the earliest known nude figure carved in the round in this country, originally identified the Boston post office.

Samuel McIntire (1757–1811) was another prominent 18th-century American woodcarver. In 1798, he turned his hand to portraiture and created a bust of Governor John Winthrop.

Works by the Skillins and McIntire are marked by a primitive awkwardness but show a growing awareness of the European sculpture tradition.

After the Revolutionary War, the new nation had heroes to celebrate and a distinct image to forge. William Rush (1756–1833) of Philadelphia was well-placed to pursue woodcarving as an art rather than a craft. The son of a ship's carpenter and assistant to an English figurehead carver, Rush was interested in creating allegorical figures based on Classical models to represent the ideals of the new United States of America.

LOOK FOR:

Primitive awareness of the European sculpture tradition
Figures from Classical mythology
Use of Classical-style drapery
Accurate depiction in portraiture
Emerging interest in anatomy

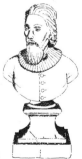

Samuel McIntire
Governor John Winthrop, 1798
Wood, h. 15½"
Courtesy American Antiquarian Society, Worcester, Mass.

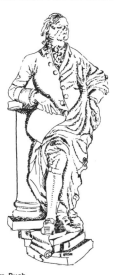

He made the transition from carving figureheads to creating three-dimensional statues. His *George Washington* was one of the first attempts by a sculptor to capture the stature and significance of the best-loved of America's leaders. The statue reveals Rush's desire to identify himself with the great sculptors of Europe. It represents the apex of early American carved wood sculpture, predicting the direction of American marble sculpture.

William Rush
George Washington, 1814
Painted pine, h. 73″
Independence National Historical Park Collection,
 Philadelphia

Rush learned the details of European sculpture from the illustrations in imported books. While his work acknowledges that tradition, it has a naturalism and vitality that is particularly American. Like his contemporary, the painter John Singleton Copley, Rush pursued honesty rather than the idealism that was the popular style in 18th-century England. In his concern for realism, Rush began to define one of the most enduring characteristics of American art.

John and Simeon Skillin Jr.
Mercury, 1793
Wood, h. 42″
The Bostonian Society, Old State House,
 Boston

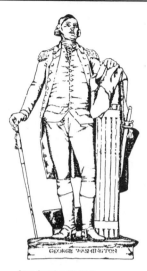

Jean Antoine Houdon
George Washington, 1788
Marble, h. 74"
The Virginia State Capitol, Richmond

When Americans wanted icons for their newly independent nation, they looked to Europe for artists. French and Italian sculptors received the larger commissions because of their professional training and their knowledge of working in marble.

The Virginia General Assembly wrote Thomas Jefferson in Paris for his advice on the choice of a sculptor for a statue of George Washington to be placed in the new Capitol building. He replied, "There could be no question raised as to the sculptor who should be employed, the reputation of Mons. Houdon, of this city, being unrivaled in Europe." (The same Mons. Houdon had just finished a bust of Mr. Jefferson.)

Jean Antoine Houdon (1741–1828) traveled to the United States to prepare a life mask, take measurements and model a terra cotta bust of Washington. His journeying across the Atlantic instead of working in Paris from a painted portrait was a bow to the importance of the subject.

Neoclassicism was the style of the day. Sculptors depicted the gods and heroes of the Classical age and clothed contemporary heroes in the robes of antiquity to demonstrate the significance of their deeds.

George Washington requested that he be portrayed in his own clothes rather than those of a Roman senator. Houdon acquiesced to his wishes and employed Classical symbolism tempered by the American concern for reality.

LOOK FOR:

Heroic subjects
Smooth marble surfaces
Classical symbolism

Jean Antoine Houdon
Thomas Jefferson, 1785
Plaster, h. 21½"
New-York Historical Society, New York

Early in the 19th century, American sculptors began traveling to Italy to learn the techniques of the masters and to have access to the plentiful marble supply and the experienced marble cutters. Living in Italy had other advantages as well for the apprentice artists: working from live, often nude models was an accepted practice among Italians but condemned as immoral in the United States. The great sculptural works of the Classical and Renaissance styles were close at hand. And life in Italy was inexpensive. By 1840, three American sculptors were firmly established in Italy.

Horatio Greenough (1805–1852) went to Rome in 1825 after studying classics and anatomy at Harvard. Subsequently he settled in Florence. In 1832, Greenough received the first major commission given to an American sculptor. The U.S. Congress selected him to sculpt a monumental image of George Washington for the rotunda of the Capitol.

Horatio Greenough
George Washington, 1840
Marble, h. 136"
National Museum of American Art,
 Smithsonian Institution, Washington, D.C.
 Transfer from the U.S. Capitol

Greenough based the facial features of his work on Houdon's bust. For the body, he used as his model the revered, seated *Zeus* created by the Greek sculptor Phidias. Once again, the American bent for realism was combined with the Classical ideal.

LOOK FOR:

Contemporary heroes in Classical
 poses and garments
Figures from Classical mythology
Concern for anatomical accuracy
Perfection of minute details

Horatio Greenough
Castor and Pollux, 1847–51
Marble, h. 34⅝"
Courtesy, Museum of Fine Arts, Boston.
 Bequest of Mrs. Horatio Greenough

14

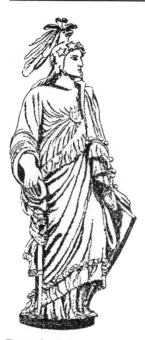

Thomas Crawford
Statue of Freedom, 1863
Bronze, h. 19½'
United States Capitol Art Collection,
 Washington, D.C. Courtesy, Architect
 of the Capitol

The symbolism of the statue equated Washington with the supreme Greek god and the United States with the glory of 5th-century democratic Athens.

Greenough's *George Washington* took its place in the Capitol rotunda in December of 1841. The majority of Americans were critical of the work. Greenough, who saw part of his mission as raising the standards of artistic taste in America, graciously accepted the criticism.

Hiram Powers (1805–1873) was a mechanic-turned-sculptor whose talents were discovered and underwritten by a leading citizen of Cincinnati, Ohio. Using this patronage, Powers moved to Washington, D.C. and established his reputation as a skilled portrait sculptor with a likeness of President Andrew Jackson.

Believing the face to be the "true index of the soul," Powers strove to portray the inner qualities of his subjects as well as to reproduce faithfully their physical appearances. Jackson encouraged him: "Make me as I am, Mr. Powers, and be true to nature always . . . "

By 1840, Powers was settled in Italy. Intent on creating some "ideal" pieces, he began work on *The Greek Slave*. His objective was to show the ideal female figure. At the 1851 Crystal Palace Exposition in London, *The Greek Slave* revolved slowly on a pedestal to great acclaim. Like other Powers sculptures, this one was admired for its exceedingly smooth, fluid, silky, fleshlike surfaces.

When Powers sent the statue on a tour of the United States in 1847, he made sure she was accompanied by an explanation of her nudity.

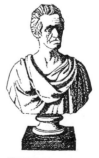

Hiram Powers
Andrew Jackson, 1835
Marble, h. 34½"
The Metropolitan Museum of Art,
 New York

This was to be the American public's first mass exposure to a nude sculpture. The clergy felt bound to make declarations about the figure's acceptability, endorsing the explanation that as a Greek slave of Turkish infidels the manacled maiden had no control over the amount of clothing she wore. The clergy added that the work portrayed her Christian virtue, symbolized by the cross at her side, showing that she remained steadfast in her faith despite her circumstances.

The *Greek Slave*'s appearances during the two-year American tour grossed $23,000. Powers took orders for marble copies at $4,000 each and eventually produced six versions.

Thomas Crawford (1813?–1857) started his career as a wood and stone carver, producing gravestones and architectural ornament. After he moved to Rome, he became the strongest American proponent of the Neoclassical style. During the expansion of the Capitol, Crawford was chosen to design the sculpture in the Senate pediment, the bronze doors for the House and Senate and the nineteen-foot *Statue of Freedom* crowning the dome.

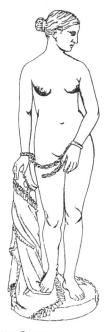

Hiram Powers
Greek Slave, 1847
Marble, h. 65½"
Collection of The Newark Museum, N.J. Gift of Franklin Murphy, Jr. 1926

Thomas Crawford
Apotheosis of Democracy, 1855
Marble, w. 60'
East Front, U.S. Capitol
United States Capitol Art Collection, Washington, D.C. Courtesy, Architect of the Capitol

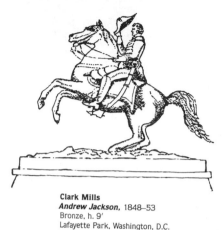

Clark Mills
Andrew Jackson, 1848–53
Bronze, h. 9'
Lafayette Park, Washington, D.C.

Bronze sculptures of American statesmen began to populate parks and squares in the mid-19th century. American sculptors working in bronze strove to forge a specifically American style that relied upon realism and naturalism rather than the idealism so prevalent in Neoclassicism.

Clark Mills (1815–1883) represents the triumph of American ingenuity. His *Andrew Jackson,* the first American-cast equestrian statue, was unveiled in 1853 in Lafayette Park across from the White House. Its design is totally unhampered by Neoclassical precedents. Mills, who had never done anything more ambitious than a stone bust and had never seen an equestrian statue, dared to cast a rearing horse. The support of the entire statue is on two legs rather than four. A weighty tail counterbalances the horse's prancing front quarters.

Mills' bronze-sculpture-casting foundry in Washington, D.C., enjoyed great success. He cast numerous pieces, including Crawford's *Statue of Freedom.*

Henry Kirke Brown (1814–1886) returned to New York after four years in Italy where he realized he wanted

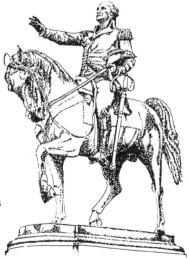

Henry Kirke Brown
George Washington, 1853–56
Bronze, h. 13½'
Union Square Park, New York

to explore indigenous American themes rather than trying to fit American subjects into the Neoclassical mold. Like Mills, he established one of the first bronze-casting foundries. His opened in Brooklyn in 1848.

Brown's equestrian statue of George Washington combines the American quest for realism with the great European tradition of equestrian statues. Although *George Washington* is his most famous statue, Brown established his reputation sculpting portrait busts and Indian themes. He lived among the Indians, observing and sketching, in order to achieve realistic renditions in bronze.

Thomas Ball (1819–1911) created numerous cabinet busts, which are small portrait busts of eminent people designed to be reproduced and sold in quantity. His best-known single bronze work is the *Emancipation Monument*. This work exemplifies Ball's straightforward style, which was based on direct observation and accurate representation. The slave's head in *Emancipation Monument* is modeled on a photograph of Archer Alexander, the last man to be recaptured under the Fugitive Slave Law.

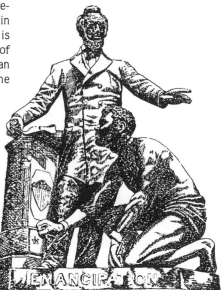

Thomas Ball
Emancipation Monument, 1874
Bronze, lifesize
Lincoln Park, Washington, D.C.

LOOK FOR:

Bronze sculptures in public parks and squares
Natural poses and gestures and contemporary dress
Realistic portraits
Smooth, polished bronze surfaces

18 Storytelling in Marble

A new generation of sculptors went to Italy in the second half of the 19th century. Among these artists were the first American women, Anne Whitney, Harriet Hosmer, Emma Stebbins, Margaret Foley and Edmonia Lewis. They created works that were sentimental favorites of the high Victorian era.

William Wetmore Story (1819–1895) was at the center of the second wave of Americans in Italy. Two of his works, *Cleopatra* (1858) and the *Libyan Sibyl* (1861), were selected by Pius IX to represent the Papal state at the 1862 International Exposition in London. Henry James assessed Story's achievement as resulting more from the tales the pieces told than from the sculptural form. "It was still the age in which an image had, before anything else, to tell a story."

Randolph Rogers (1825–1892) was another popular storyteller. His *Nydia, the Blind Girl of Pompeii*, based on a well-known novel of the period, spawned fifty marble replicas. William Rinehart (1825–1874) won widespread acclaim with his sculptures of the Classical lovers *Hero* (1869) and *Leander* (c. 1858). And Harriet Hosmer (1830–1908), whose independent spirit created a stir in Rome, became financially self-sufficient in the late 1850s with reproductions of her playful *Puck* and *Will-o'-the-Wisp*.

Randolph Rogers
Nydia, the Blind Girl of Pompeii, 1856
Marble, h. 54"
Pennsylvania Academy of the Fine Arts, Philadelphia

Americans of the era treasured these small marble figures as status symbols or mementos of a trip abroad. These narrative statuettes supplanted cabinet busts in the parlors of American families.

LOOK FOR:

Figures from romantic stories
Sentimental poses
Figures from stories set in exotic lands

Harriet Goodhue Hosmer
Puck, 1856
Marble, h. 30½"
National Museum of American Art, Smithsonian Institution, Washington, D.C. Gift of Mrs. George Merrill

John Quincy Adams Ward (1830–1910) studied with Henry Kirke Brown and, like his mentor, worked from direct observation to achieve a naturalistic style. Ward lived with the Indians and sketched them to produce the first piece that gained him widespread praise, *Indian Hunter.* Another early work, *Freedman* (1863), expressed an abolitionist sentiment and emphasized Ward's devotion to animated realism.

Soon Ward was creating monumental commemorative bronze sculptures for city parks and squares. These large-scale portrayals of American heroes, many of them created in collaboration with the architect Richard Morris Hunt, made Ward's reputation. Although Ward did not study in Paris, the influence of the Ecole des Beaux-Arts shows in the lively naturalistic surface treatment of the *Henry Ward Beecher Monument.*

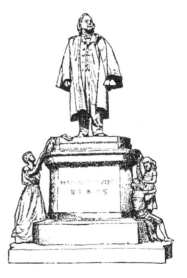

In the last quarter of the 19th century, academies dominated the American art world. Ward was preeminent in those academies. In 1874, he was elected president of the National Academy of Design. And when the National Sculpture Society was founded in 1893, he was named its first president.

John Quincy Adams Ward
Henry Ward Beecher Monument, 1891
Bronze, h. 96″
Cadman Plaza, Brooklyn, N.Y.

LOOK FOR:

Natural poses of subjects
Richly textured surfaces
Monumental commemorative bronzes

John Quincy Adams Ward
Indian Hunter, 1864
Bronze, h. 16″
The New-York Historical Society, New York

John Rogers (1829–1904) was a consummate storyteller and perhaps the most American of all sculptors. His skill in composition, his attention to detail and his choice of everyday activities (genre scenes) as his subject matter appealed to middle-class Americans the way no other work of his era did.

Like other aspiring sculptors, Rogers made the obligatory tour of Europe. He returned discouraged, feeling out of sync with the prevailing Neoclassicism. That style eliminated the very detail that he craved. He wanted to be specific about time and place; the Neoclassical masters sought to convey the universal without reference to the particular.

The Slave Auction (1859) was the piece that gave Rogers his first real financial success. New York galleries were afraid to sell such an anti-slavery statement, and Rogers hired a black man to peddle the sculptures on the street. They were an instant hit with the abolitionists and spread his reputation as a sculptor of American genre scenes.

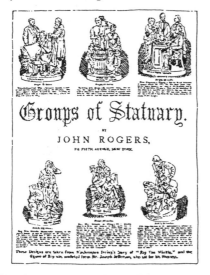

Title page: ***Descriptive Catalogue and Price List of Group Statuettes from the Studio of Mr. John Rogers.*** New York: Rogers Statuary Company, 1895.

LOOK FOR:

Genre scenes (anecdotal scenes from everyday life)
Social commentary, particularly anti-slavery
Focused, multiple-figure compositions
Informal groupings with a natural appearance
Realistically rendered details

Rogers' mass production process, which he perfected after a great deal of experimentation, allowed him to make his sculptures available in inexpensive plaster reproductions. First he made clay models. Then he cast them in bronze to retain maximum detail. From the bronzes came flexible molds for the plaster models that he painted either slate gray or putty brown. He produced two tabletop sizes, one in the 8- to 13-inch range and the other 22 to 24 inches.

He sold his work through his own mail order catalog, distributed nationwide. An average price of $15 put his models within reach of many American households. By 1893, he had sold 80,000 pieces. His work adorned living rooms all across the land.

Taking the Oath and Drawing Rations exemplifies Rogers' skill in the multiple-figure compositions that he introduced. He created a compact arrangement of figures around one focal point, and he captured a slice of life.

Rogers appealed to the American preference for comprehensible familiar themes instead of obscure Classical subjects. An article in the November 1868 issue of *Atlantic Monthly* described his accomplishment this way: "The little groups by John Rogers, simplest realism as they are, and next to the lowest orders of true art, carry more significance than all the classic sculpture in the country, and will possess historic value which we cannot overestimate."

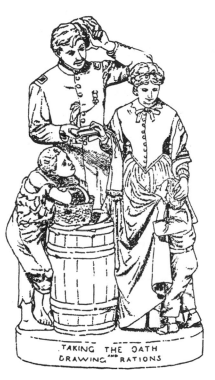

John Rogers
Taking the Oath and Drawing Rations, 1866
Painted plaster, h. 23"
National Museum of American Art, Smithsonian Institution, Washington, D.C. Gift of Robert O. Werlich

Augustus Saint-Gaudens (1848–1907) was the creative genius of late 19th-century American sculpture. Art historian John Wilmerding has said, "More than anyone in America, he was responsible for carrying sculpture from allegorical Neoclassicism to heroic realism, from single- to multiple-figure compositions, and from stone carving to bronze casting." Like his contemporary, the painter Thomas Eakins, he could take the ordinary and transform it into something monumental. He combined factual accuracy with psychological expressiveness.

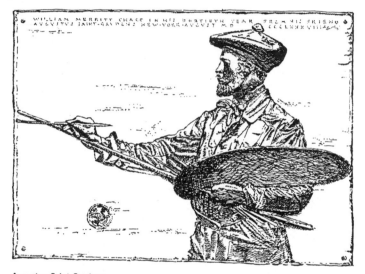

Augustus Saint-Gaudens
Portrait of William Merritt Chase, 1888
Bronze bas-relief, h. 21½"
Collection, American Academy of Arts and Letters, New York

Saint-Gaudens apprenticed with cameo cutters in New York, thereby cultivating the skill of intricately detailed relief carving. In 1867, he went to Paris to study at the Ecole des Beaux-Arts. There he developed his sense of sculptural form, an interest in richly modeled surfaces reflecting light and shade and the ability to create unified compositions with detailed parts.

In travels to Rome, Saint-Gaudens affirmed his commitment to Renaissance sculpture, which would inspire him throughout his career. But it was his own personal vision that led to his powerful synthesis of truth and beauty, of the real and the ideal.

Saint-Gaudens collaborated with architects on monumental public projects, incorporating bases, seating areas and inscriptions as essential elements. He created one of his most famous works, a memorial to Henry Adams' wife, with architect Stanford White. The *Adams Memorial* introduced a new kind of funerary memorial. The enigmatic figure is not clothed in the sentimentality characteristic of the Victorian era. Rather than depicting a specific grief, Saint-

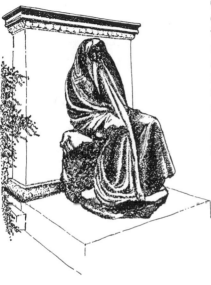

Gaudens conveyed the universal concept of nirvana, the peace of total repose when the soul is released from constant searching. An introspective spiritual communion with the work, instead of rational analysis, evokes its meaning.

As Henry Adams said, "Like all great artists, Saint-Gaudens held up the mirror and no more."

Augustus Saint-Gaudens
Adams Memorial, 1886–91
Bronze, h. 72″
Rock Creek Cemetery, Washington, D.C.

LOOK FOR:

Integration of architecture and sculpture
Relief portraits incorporating
 inscriptions as design elements
Impressionistic surfaces (uneven
 modeling strokes, rough texture)
Compositional strength and unity
Psychological expressiveness

Augustus Saint-Gaudens
The Puritan, 1887 (this cast 1899)
Bronze, h. 31″
The Metropolitan Museum of Art, New York

Between 1876 and 1915, American sculpture achieved greater stature, primarily in its role as handmaiden to architecture in the grand constructions of the American Renaissance. This period was dominated by Beaux-Arts-trained architects and sculptors. An emerging class of wealthy businessmen commissioned architecture and sculpture to reflect their status and to connect them with past ages of comparable material glory. Residences modeled on Italian Renaissance palaces and French chateaux called for monumental pieces of sculpture as ornament. Public buildings reflecting the grandeur of a mightily prosperous nation required larger-than-life statues to commemorate war heroes and benefactors. Daniel Chester French (1850–1931) responded directly to the patronage of the age. His work glorified such concepts as prosperity, wisdom and progress.

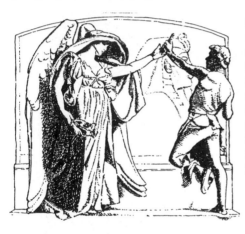

French achieved his first success with the *Minute Man*, cast from the bronze of old cannons. From this appealing portrayal of an American hero, French moved on to dominate the sculpture scene of the American Renaissance. He studied in both Paris and Florence, incorporating influences from each culture in his

Daniel Chester French
The Angel of Death and the Sculptor
Marble copy (1926) of original bronze (1891–92), h. 91"
The Metropolitan Museum of Art, New York

LOOK FOR:

Fountains and monuments
beautifying urban parks and
squares
Sculpture embellishing buildings
Nationalistic, didactic and
moralistic subject matter
Large-scale celebrations of
American accomplishments
Play of light and shadow over
impressionistic surfaces

Daniel Chester French
Minute Man, 1874–75
Bronze, h. 84"
Concord, Massachusetts

renowned commemorative portraits and allegorical groups. His best-known work is the seated *Lincoln* (1922) in the Lincoln Memorial in Washington, D.C.

Frederick MacMonnies (1863–1937), another Beaux-Arts-trained sculptor, brought a playful rococo spirit to the monumental age. His *Bacchante and Infant Faun* was rejected as inappropriate for the Renaissance public library in Boston. MacMonnies did receive one of the choice sculptural commissions at the World's Columbian Exposition of 1893 in Chicago— the fountain at the head of the grand lagoon. MacMonnies created the *Barge of State,* an unabashed celebration of American pride.

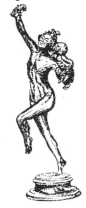

Frederick MacMonnies
Bacchante and Infant Faun, 1894
Bronze, h. 34"
Philadelphia Museum of Art

The Columbian Exposition, one of four great exhibitions of architecture and sculptural decoration staged as the century turned, epitomized the spirit and visual imagery of the American Renaissance. Architects, sculptors and painters converged in Chicago and collaborated on the creation of the gleaming "White City," a monumental Renaissance ensemble of buildings encircling an artificial lagoon peopled with sculptures. French's 64-foot-tall *Republic* and MacMonnies' *Barge of State* faced each other across the grand lagoon. Midway between those two works, Saint-Gaudens' *Diana* graced the dome of the Agriculture Building. Most of the White City was made of a composition of plaster and straw which has not survived. Today the exposition's glories are available only in photographs, but its influence can be seen in the architecture, sculpture and city planning of Washington, D.C.

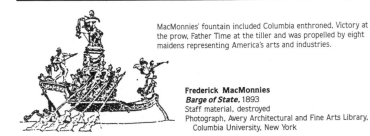

MacMonnies' fountain included Columbia enthroned, Victory at the prow, Father Time at the tiller and was propelled by eight maidens representing America's arts and industries.

Frederick MacMonnies
Barge of State, 1893
Staff material, destroyed
Photograph, Avery Architectural and Fine Arts Library,
 Columbia University, New York

The founding of the National Sculpture Society in 1893 influenced the direction of American sculpture. The society, which quickly became the arbiter of sculptural taste, promoted representational works, thus extending the preeminence of that form for decades into the 20th century.

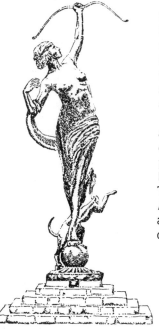

With the Ecole des Beaux-Arts and the National Academy of Design, the National Sculpture Society fostered American Academicism, a movement that grew out of and was inspired by the same philosophy as the American Renaissance. The sculptors in the two categories overlapped, and their stylistic characteristics merged.

Differences in subject matter, scale and scope distinguish the two styles. Academic sculptures are smaller, with more personal themes. Academic works tend to be more delicate, feminine and genteel. Their emphasis on beauty, as in *The Singing Boys* by Herbert Adams (1855–1945), appealed to the sensibilities of upper middle class Victorian families.

Anna Hyatt Huntington
Diana of the Chase, 1922
Bronze, h. 96"
Brookgreen Gardens, Murrells Inlet, South Carolina

LOOK FOR:

Representations of family life
Feminine, genteel subjects
Persistence of Classical themes
Delicacy of modeling
Emphasis on beauty

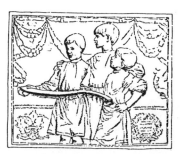

Herbert Adams
The Singing Boys, 1894
Marble, h. 36"
The Metropolitan Museum of Art, New York

A. Stirling Calder (1870–1945) moved between the two styles. His *Man Cub*, a fine example of American Academicism, is a portrait of his young son Alexander, who was destined to become one of America's foremost 20th-century sculptors. The senior Calder achieved much of his recognition as an organizer of and exhibitor in the world's fairs early in the 20th century.

Bessie Potter Vonnoh (1872–1955) portrayed the joys of motherhood and the innocence of childhood. Her sculpture has been likened to Mary Cassatt's painting. Vonnoh's *Young Mother* was one of her most popular genre pieces.

As American Academicism dominated the sculpture scene, modernism was changing the look of painting. The academies

Bessie Potter Vonnoh
The Young Mother, 1896
Bronze, h. 14½"
The Metropolitan Museum of Art, New York

refused to bend to the new abstraction. Because most sculptors depended for their livelihood on inclusion in the academies' annual exhibitions, their work continued to be based on recognizable Classical or Renaissance models.

Anna Hyatt Huntington's (1876–1973) *Diana of the Chase* shows the persistence of Classical themes. The academies accepted the new impressionistic surface treatments but would not allow the disintegration of form.

A. Stirling Calder
The Man Cub, c. 1901
Bronze, h. 44"
The Metropolitan Museum of Art, New York

By the end of the 19th century, the Cowboy and the Indian had become romanticized images of a disappearing past. Certain sculptors, realizing that western settlement had been achieved at the expense of the native American population, began to portray the Indians' heroic qualities. As noble Indians appeared in bronze, so did gallant cowboys, horses and other animals of the wild West.

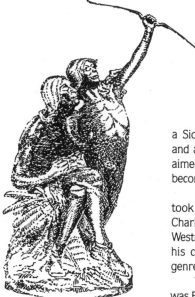

Hermon Atkins MacNeil (1866–1947) was one of the first sculptors to turn exclusively to the Indian theme. His *Sun Vow* portrays a Sioux initiation ceremony with dignity and accuracy. If the boy's arrow, which is aimed at the sun, disappears, then he will become a warrior.

Cyrus E. Dallin (1861–1944) also took the Indian as his primary subject. Charles Russell (1864–1926), the noted Western painter, took up sculpture late in his career. He created tabletop Indian genre scenes full of action.

The most famous cowboy sculptor was Frederic Remington (1861–1909). He was first known as a magazine illustrator whose depictions of Western scenes, particularly for *Harper's Weekly*, had a large popular following. When he turned to sculpture in 1895, Remington translated his concern for authenticity and detail into three dimensions. He was not timid in his first venture into the new medium. *The Bronco Buster* shows the horse in a daring rearing pose. This

Hermon Atkins MacNeil
Sun Vow, 1898
Bronze, h. 73"
The Metropolitan Museum of Art, New York

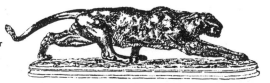

Alexander Phimister Proctor
Stalking Panther, 1893
Bronze, h. 10¼"
Corcoran Gallery of Art,
 Washington, D.C.

piece was so popular that Remington cast more than 200 copies of it. His subsequent bronze tabletop (23 to 32 inches high) Western genre scenes were artistically and financially successful.

Edward Kemeys (1843–1907) and Alexander Phimister Proctor (1860–1950) chose the wild animals of North America as the subjects of their work. Their sculptures capture the vanishing breeds of the mountains and the plains.

All the Western Genre artists pursued a realism based on intimate knowledge of their subjects. They either lived in the West or traveled there extensively. Theirs can be considered some of the most specifically American of all sculpture because of the unique subject matter and the highly naturalistic style.

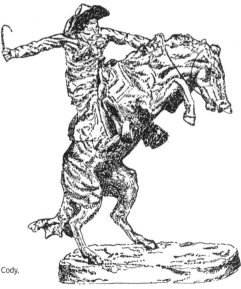

Frederic Remington
The Bronco Buster, 1895
Bronze, h. 23⅜"
Buffalo Bill Historical Center, Cody, Wyoming

LOOK FOR:

Realistic cowboy poses
Native animals of the wild West
Monuments to the vanquished native people
Genre scenes portraying Indian rituals
Abundant detail and action

William Rimmer (1816–1879) eschewed Neoclassicism, bland naturalism, genre and realistic portraiture—all the popular styles of his day—and created a sculpture uniquely his own. He explored the expressiveness of human and animal bodies, particularly the dynamism that comes from working muscles. Rimmer won more renown for his lectures on anatomical drawing than for his art work.

George Grey Barnard (1863–1938), another independent sculptor who explored concepts and forms anticipating the modern age, was the antithesis of the contemporary academic artist. He tried to show through his expressive human forms the clash of ideas and emotions. Barnard's aim was to bypass the viewer's rational mind and directly engage the feelings. Like Auguste Rodin in Paris, Barnard revealed the most powerful human emotions without abandoning representational form. His expressionistic treatment of composition and surface details recalls the work of Michelangelo.

Barnard's *Struggle of Two Natures in Man* achieved great success in Paris in 1894; and *Solitude*, part of a series entitled *The Urn of Life*, was exhibited at the Armory Show of 1913 in New York.

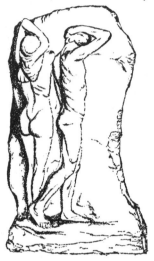

George Grey Barnard
Solitude, 1905–06
Marble, h. 21¾"
Vassar College Art Gallery, Poughkeepsie, New York.
Gift of Mary Thaw Thompson '77

LOOK FOR:

Appeal to emotion rather than reason
Influence of Michelangelo
Tension visible in muscles
Expression of emotions through the human form

William Rimmer
The Falling Gladiator, 1861
Bronze, h. 63¼"
Courtesy, Museum of Fine Arts, Boston. Gift of Miss Caroline Hunt Rimmer, Mrs. Adelaide R. Durham, various subscribers

Despite the dominance of American Academicism, a few sculptors rejected upper middle class Victorian sensibilities in order to explore the lives of the working class and the urban poor. These artists worked in the representational style acceptable to the academies; their subjects, however, did not have the academies' approval. Museums purchased their realistic pieces of construction workers, prize fighters and men at war; but private patrons continued to prefer the pleasurable family scenes of such sculptors as Bessie Potter Vonnoh.

Abastenia St. Leger Eberle (1878–1942) invited neighboring tenement children into a playroom in her studio in Manhattan's Lower East Side. There

they became subjects for her sculptures like *Roller Skating* (1910). Eberle's work bears a remarkable affinity to the paintings of socialists Robert Henri and John Sloan, leaders of the Ash Can School.

Mahonri M. Young (1877–1957), grandson of Brigham Young, left Salt Lake City for the East where he sculpted laborers hefting pickaxes and pushing wheelbarrows. Gertrude Vanderbilt Whitney (1875–1942), founder of the Whitney Museum of American Art in 1930, was inspired by working in French hospitals during World War I to abandon the ideal in order to represent the reality of war. In the twenties, Saul Baizerman (1889–1957) used his new technique of hammered metal to depict scenes from working class life in his series *The City and the People.*

Abastenia St. Leger Eberle
Windy Doorstep, 1910
Bronze, h. 13½"
Worcester Art Museum, Worcester,
Massachusetts

LOOK FOR:

Representation of the
 urban poor
Scenes of ordinary
 people at work
Impressionistic handling
 of surfaces

Mahonri M. Young
Man with Wheelbarrow, 1915
Bronze, w. 15¼"
Collection, Whitney Museum of
 American Art, New York. Gift of
 Gertrude Vanderbilt Whitney

European modernism caused a sensation when it showed its fractured face to the American public at the Armory Show of 1913 in New York City. "There was no American artist who saw this show but was forced to revalue his artistic concepts," according to the painter Stuart Davis.

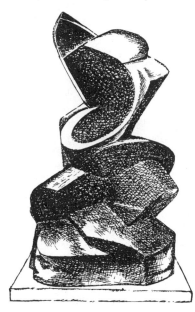

The predominant images of modernism at that landmark show were the sharp angles, flat planes and fragmented forms of Cubism. Pablo Picasso, one of the creators of Cubism in Paris, explored the new aesthetic in sculpture. His *Woman's Head* (1909) was one of the Armory Show's pivotal works. Picasso's collages and his cardboard sculptures began to eliminate the boundary between painting and sculpture.

Max Weber
Spiral Rhythm, 1915
Bronze, h. 24⅛"
Hirshhorn Museum and Sculpture Garden, Washington, D.C. Gift of Joseph H. Hirshhorn, 1966. Courtesy, Forum Gallery, New York

LOOK FOR:

Abstract and simplified forms
Flat planes and sharp angles
Incorporation of voids
Fragmentation of form

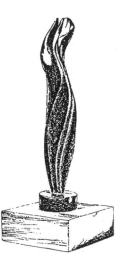

Robert Laurent
The Flame, c. 1917
Wood, h. 18"
Collection, Whitney Museum of American Art, New York. Gift of Bartlett Arkell

After study in Paris, American painter Max Weber (1881–1961) created *Spiral Rhythm,* an early American Cubist sculpture. Robert Laurent (1890–1970) and John Storrs (1885–1956) sculpted abstract Cubist forms in the teens and twenties.

Cubist sculptors simplified, abstracted and reduced recognizable objects to three-dimensional intersecting geometric shapes. They shattered curvilinear subjects, like the human body, into fragments. They freed planar forms from their traditional role as object definers and presented them for their own qualities.

American Cubists had little influence on subsequent sculpture. Their flat planes and sharp angles were a superficial gloss on representational forms. But their counterparts in France explored the multiple perspectives and simultaneity that originally inspired Cubism.

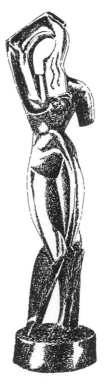

Alexander Archipenko
Woman Combing Her Hair, 1915
Bronze, h. 13¾"
The Museum of Modern Art, New York

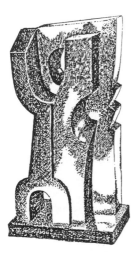

John Storrs
Composition Around Two Voids, c. 1934
Stainless steel, h. 20"
Collection, Whitney Museum of American
 Art, New York. Gift of Monique Storrs Booz

34 Dada Challenges

Dada, an international movement, originated in 1916 in a Zurich cabaret and quickly spread beyond Swiss borders. The pervasive pre-World War II mood of despair and disillusionment linked artists and literary figures from many countries and made them receptive to Dada's nihilistic message: "The world today doesn't make sense so the art doesn't make sense. Art is dead—anything goes."

Dada promoted an attitude of total freedom, a throwing off of the shackles of tradition. Dada encouraged artists to push back the boundaries defining and limiting their work and to explore new paths.

In 1913, the French artist Marcel Duchamp (1887–1968) selected his first ready-made, *Bicycle Wheel*, and introduced the found object as part of the sculptural repertoire. Chosen as a commonplace machine-made object, placed upside down on a kitchen stool and labeled an "objet d'art," *Bicycle Wheel* was shocking and provocative.

Duchamp moved to New York City in 1915 and two years later presented his greatest challenge to the American art world. He submitted an upside-down urinal titled *Fountain* to the Society of Independent Artists' exhibit. In contrast to the academies' selective juried shows, the Society of Independent Artists accepted and exhibited all work entered in its shows. *Fountain*, however, was

Marcel Duchamp
In Advance of the Broken Arm, 1945
 replica of 1915 original
Wood and metal, h. 47¾"
Yale University Art Gallery, New Haven,
 Connecticut

LOOK FOR:

Startling juxtapositions and fresh perspectives
Commonplace objects selected to challenge the
 status quo
Challenges to the notion of what constitutes art
Outrageous and irreverent insistence on a new way of
 looking at a familiar object

Morton L. Schamberg
God, c. 1916
Mitre box and plumbing trap, h. 10½"
Philadelphia Museum of Art

too outrageous for the society, which removed the ready-made from the 1917 show and refused to exhibit it.

Dada, with its emphasis on freedom and exploration, could not be contained in one identifiable style. Artists with styles as diverse as Man Ray's (1890–1976) and Morton Schamberg's (1881–1918) were part of the Dadaist movement.

Man Ray's *Cadeau,* an iron with a row of tacks jutting out from its pressing surface, thus mocking its purpose, typifies the artist's frequent juxtaposition of the useful with the harmful. Schamberg's *God,* a plumbing trap in a mitre box, explores

Man Ray
Cadeau (Gift), 1963 replica of 1921 original
Mixed media, h. 5"
Collection, Mr. and Mrs. Michael Blankfort
© 1989 ARS N.Y. / ADAGP

humanity's relationship to the mechanical and asks whether man's creations have become his deity.

Dada's message empowered subsequent artists to go beyond the acceptable norms, to challenge the status quo and to explore new materials and images. Dada challenged the art audience to expand its ideas of what constitutes art.

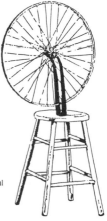

Marcel Duchamp
Bicycle Wheel, 1951 replica of 1913 original
Metal and wood, h. 50½"
The Museum of Modern Art, New York

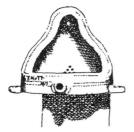

Whether [the artist] with his own hands made the fountain or not has no importance. He chose it. He took an ordinary article of life, placed it so that its useful significance disappeared under the new title and point of view—created a new thought for that object.

—Marcel Duchamp

Marcel Duchamp
Fountain, 1917
Location unknown
Known through photograph by Alfred Stieglitz, Philadelphia Museum of Art

The experimentation started by the Armory Show was interrupted by World War I, when isolation and uncertainty prompted a reaction against modernism and a return to more traditional human-centered imagery. In the hands of Jo Davidson (1883–1952) and Isamu Noguchi (1904–1988), portraits displayed a new power and vitality drawn from the Cubists' freer treatment of sculpted surfaces. Portraiture of this period also carried nationalistic overtones, as in the monumental presidential portraits sculpted on the face of Mount Rushmore by Gutzon Borglum (1867–1941) between 1927 and 1939.

Elie Nadelman
Man in the Open Air, c. 1915
Bronze, h. 54½"
The Museum of Modern Art,
New York

Paul Manship (1885–1966) and Elie Nadelman (1882–1946) merged stylized natural forms with abstract geometric shapes to create the streamlined sculptures favored by a war-weary and suddenly cynical public. Manship's works made reference to the Greek tradition but with linear surface patterns that were unmistakably modern. Nadelman drew upon American folk art for his smooth, simplified, curvilinear forms highlighted with color.

Gaston Lachaise (1882–1935) accentuated the size and sensual curves of the female figure, imbuing it with a new expressive power.

Robert Laurent's reintroduction of direct carving techniques early in the 20th century influenced several of his fellow artists, notably William Zorach (1889–1966) and John B.

LOOK FOR:

A return to human and animal figures
Stylized, streamlined forms
New power and vitality of portraiture
Abstracted forms accentuating decorative aspects
Unfinished quality of carved surfaces

Gaston Lachaise
Floating Figure, 1927
Bronze, w. 96"
The Museum of Modern Art, New York

Flannagan (1895–1942). The people and animals in Zorach's rough-textured surfaces are recognizable figures with slightly modern lines. Flannagan's animals emerge from unsculpted rocks and delight with their humorous poses.

A distinguishing feature of this period was the loss of the avant garde spirit. Cubist artists like Laurent and Archipenko, who had created abstract sculpture in the teens, returned to naturalistic human forms in the twenties and thirties. The resurgence of the preference for recognizable subject matter was characteristic of the isolationism of the times and the rebuilding of the national image after the devastation of World War I. The Mount Rushmore project best exemplifies the attitudes of the period.

Paul Manship
Dancer and Gazelles, 1916
Bronze, h. 34¼"
Corcoran Gallery of Art,
Washington, D.C.

To do a head of Gertrude Stein was not enough . . . so I did a seated figure of her —a sort of modern Buddha.

Jo Davidson

Jo Davidson
Gertrude Stein, 1920
Bronze, h. 31¼"
Collection, Whitney Museum of American Art, New York

John B. Flannagan
Jonah and the Whale, 1937
Bronze, h. 29½"
The Minneapolis Institute of Arts

Surrealism, originally a literary movement of 1924, moved the boundaries of painting and sculpture into the world of dreams. Challenging the supremacy of the rational mind, the Surrealists advocated exploration of the unconscious and subconscious depths.

Surrealism was a positive influence for several decades. It grew out of the negativism of Dada and the new theories of Sigmund Freud. It was a European import, taking hold in the thirties and forties when its advocates settled in New York City. The Surrealists introduced American artists to psychic improvisation, the act of spontaneous creation unhindered by the rational mind. Psychic improvisation was the spark that ignited the Abstract Expressionist painters.

David Smith (1906–1965), Alexander Calder (1898–1976) and Isamu Noguchi (1904–1988) all explored Surrealist forms and eventually moved beyond them.

Joseph Cornell (1903–1972) created miniature worlds within boxes using recognizable objects and juxtaposing them to create surreal effects. Cornell's boxes have a haunting magical

Isamu Noguchi
Figure, 1945
Bronze, h. 60"
The Isamu Noguchi Garden Museum, Long Island City, New York

LOOK FOR:

Dream images and organic forms
Startling juxtapositions
Ambiguous transformations
Totemic qualities
Assemblages of found objects

Louise Bourgeois
One and Others, 1955
Painted and stained wood, h. 18¼"
Collection, Whitney Museum of American Art, New York

quality that engages the unconscious and defies attempts of the rational mind to analyze and explain.

David Hare (b. 1917) befriended the Surrealist refugees in New York and developed his own Surrealist style, which relied on psychic improvisation for its metaphoric imagery.

Frederick Kiesler (1896–1965), Louise Bourgeois (b. 1911) and Louise Nevelson (1900–1988) created large-scale Surrealist works that were intended to become part of the viewer's own space, an intrusion of the subconscious into reality. Nevelson constructed wooden walls, adding compartment upon compartment,

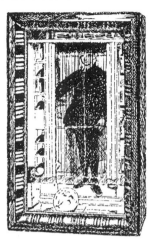

Joseph Cornell
Untitled (Medici Prince), c. 1953
Mixed media, h. 17"
National Gallery of Art, Washington, D.C.
Gift of Collectors Committee

each one holding diverse mundane objects. She applied a single color to unify each wall of stacked boxes. Her personal style surpassed its Surrealist origins and established her prominence as America's foremost female sculptor of the mid-20th century.

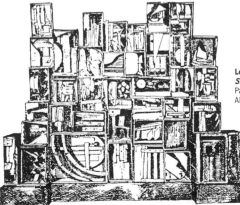

Louise Nevelson
Sky Cathedral, 1958
Painted wood, h. 115"
Albright-Knox Art Gallery, Buffalo, New
 York. George B. and Jenny R.
 Mathews Fund, 1970

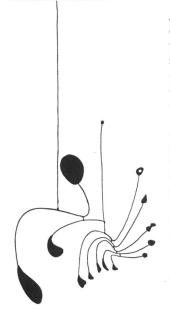

Alexander Calder
Hanging Spider, c. 1940
Painted sheet metal and wire, h. 49½"
Collection, Whitney Museum of
 American Art, New York. Mrs. John B.
 Putnam Bequest
© 1989 ARS N.Y. / ADAGP

*When everything goes right, a mobile
is a piece of poetry that dances with the
joy of life and surprises.*
 Alexander Calder

Alexander Calder
La Grande Vitesse (Top Speed), 1969
Painted steel
Vandenberg Plaza, Grand Rapids, Mich.
© 1989 ARS N.Y. / ADAGP

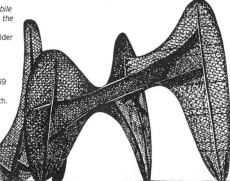

Alexander Calder (1898–1976), a third generation Philadelphia sculptor, was one of the first American sculptors to turn to abstract shapes. He said he liked "the idea of detached bodies floating in space, of different sizes and densities . . . some at rest while others move in peculiar manners."

Trained as a mechanical engineer, Calder used sheet metal and wire to invent two forms—the stabile and the mobile—in the thirties. He worked in these two forms throughout his career, refining and eventually monumentalizing them.

Calder spent much of his adult life in Paris, where he encountered paintings by Mondrian and thought how much finer the abstract colorful shapes would be if they could move. *Josephine Baker,* his first portrait made of wire, was meant to be hung so that it could move freely, foreshadowing the mobile. For his first wind-driven sculpture, *Calderberry Bush,* he used a series of balanced weights to create unpredictable motion. The *Hanging Spider* mobile shows Calder's characteristic free-floating shapes,

intersecting and redefining space in response to capricious breezes.

Calder's stabiles balance large flat metal shapes on thin tapering legs. They take advantage of the strength of steel to pose the contradiction of the massive depending upon the slender for support. As these stabiles grew, like *Top Speed,* to occupy large open city plazas, viewers could enter the space defined by the sculptures and appreciate their ironies from a different perspective.

Calder pursued an independent course and created his own individual style. Its impact, however, is evident in Kinetic Constructivism and Architectural Art.

Alexander Calder
Josephine Baker, 1926
Wire, h. 39¾"
Musée National d'Art Modern, Paris
© 1989 ARS N.Y. / ADAGP

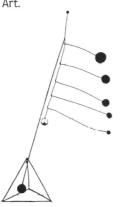

Alexander Calder
Calderberry Bush, 1932
Painted steel rod, wire, wood, and sheet
 aluminum, h. approx. 88½"
Collection, Whitney Museum of American
 Art, New York. Purchase, with funds
 from the Mrs. Percy Uris Purchase Fund

LOOK FOR:

Whimsical, colorful, simple images
Wire used to create sculptural line drawings
Mobiles (balanced, free-floating forms in motion)
Stabiles (massive steel forms resting on tiny points)

Alexander Calder
Fish, 1940
Glass, metal, wire, and cord, w. 46"
Hirshhorn Museum and Sculpture Garden,
 Smithsonian Institution, Washington,
 D.C. Gift of Joseph H. Hirshhorn, 1966

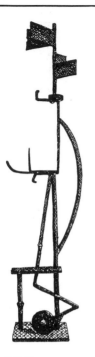

David Smith
Sentinel I, 1956
Steel, h. 89⅝"
National Gallery of Art,
 Washington, D.C. Gift of the
 Collectors Committee

David Smith (1906–1965), who ranks with Alexander Calder as a giant of 20th-century American sculpture, also worked in steel. He saw it as the quintessential American material. "The metal possesses little art history," he said. "What associations it possesses are those of this century: power, structure, movement, progress, suspension, destruction, brutality."

Smith learned welding and riveting in a Studebaker automobile plant in South Bend, Indiana. Then he moved east to study art. His paintings began to protrude from the canvas as he attached found objects. "I do not recognize the limits where painting ends and sculpture begins," he said.

After seeing Picasso's welded sculpture in a French art magazine in 1933, Smith borrowed some tools and created his first welded sculpture out of found objects. With this experiment he realized he had discovered his material and his method of working.

The *Hudson River Landscape* is a drawing-in-space. Its two-dimensional flatness exemplifies Smith's technique of composing the various parts of a piece on the ground before welding them together.

LOOK FOR:

Use of cantilevers to create tension and dynamism
Burnished, polished stainless steel cubes and beams
Welded steel drawings-in-space
Use of tools, machine parts and metal scraps
References to the human figure
Definition of space within the sculpture

David Smith
Voltri VII, 1962
Iron, h. 85"
National Gallery of Art, Washington, D.C.
 Gift of the Collectors Committee

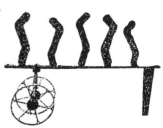

Smith's Voltri series, created in 1962 for display in Spoleto, Italy, incorporates tools, machine parts and steel scraps that he found in abandoned steel mills nearby. *Voltri VII* resembles an ancient chariot occupied by abstract figures.

His Cubi series is perhaps his best known. Constructed of burnished and polished stainless steel cubes and beams, the sculptures shimmer in the light. They appear monumental and majestic, poetic and magical. In *Cubi VI* the cantilevered parts create tension and dynamism while the surfaces dissolve into the immateriality of light.

On stainless steel surfaces, Smith created an illusion of three-dimensional depth; dancing electric filaments appear to be deeply recessed into the body of the sculpture itself. Although abstract, Smith's vertical sculptures, such as *Cubi VI* and *Sentinel I*, frequently conjure up human figures.

Smith's work belongs to no single stylistic tradition. His one constant characteristic was his inventiveness. His work had an immediate impact upon American sculpture and continues to be influential. Mark di Suvero (b. 1933) and Joel Shapiro (b. 1941) are two contemporary sculptors whose works bear homage to Smith.

David Smith
Cubi VI, 1963
Stainless steel, h. 112"
Israel Museum, Jerusalem
© VAGA New York 1989

David Smith
Hudson River Landscape, 1951
Welded steel, h. 49½"
Collection, Whitney Museum of
American Art, New York

44 **POST WORLD WAR II:** Expressionistic Abstraction

A small group of American sculptors began moving toward Expressionistic Abstraction in the years between the two world wars when abstraction was not fashionable. These sculptors were inspired by David Smith's example of working directly in metal with welding tools. They adopted the Surrealists' methods of psychic improvisation to summon images from the subconscious. They were also affected by the pathos of a deteriorating world political situation in the late 1930s.

Rather than creating carefully controlled premeditated pieces, they sculpted powerful expressive forms incorporating accident and spontaneity. Each artist evolved an individual style. These expressionistic sculptures, like the paintings of the Abstract Expressionists, manifest the artist's personal beliefs and emotions.

The viewer of Expressionistic Abstraction draws upon all his or her personal life experience to respond to the work. Depending upon the viewer, an abstract shape can be peaceful, lyrical and meditative or harsh, brutal and

Ibram Lassaw
Galactic Cluster #1, 1958
Bronze, nickel, and silver, h. 33"
Collection of The Newark
 Museum, N.J. Purchase,
 Sophronia Anderson Bequest
 Fund, 1960

LOOK FOR:

Abstract sculptures appealing to the emotions
 rather than to reason
Fluid metal alloys in open constructions
Brutally aggressive shapes and materials
Variety in surface color and texture
Compressed automobile frames
Clay, porcelain and terra cotta sculptures

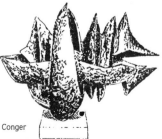

Seymour Lipton
Sea King, 1955
Nickel-silver over monel metal, h. 29½"
Albright-Knox Art Gallery, Buffalo, New York. A. Conger
 Goodyear Fund, 1956

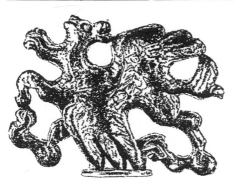

Jacques Lipchitz
Pegasus, 1944
Bronze, h. 15½"
Cincinnati Art Museum, Ohio. Gift of the Cincinnati Arts
Center

aggressive. Beyond reason's comprehension but definitely engaging the emotions, these works were a new experience for the American public.

Because of the disjointed times, many of the artists were seeking answers to ultimate questions. They got a resounding answer from Jean Paul Sartre in 1947 when the English translation of his essay on Existentialism appeared in the U.S. Sartre wrote, " Man . . . exists only to the extent that he fulfills himself; he is therefore nothing else than the ensemble of his acts."

Jacques Lipchitz (1891–1973), working in traditional materials, imbued abstract sculpted forms with emotional expressiveness. Using new flexible metal alloys, Theodore Roszak (1907–1981), Ibram Lassaw (b. 1913), Seymour Lipton (1903–1987) and Herbert Ferber (b. 1906) created textures, colors and shapes as they worked.

The experiments of ceramicist Peter Voulkos (b. 1924) in Los Angeles transformed craft into art and initiated a California school of ceramic sculptors. His style in clay was similar to Reuben Nakian's (1897–1986) in terra cotta.

The powerful compressed automobile carcasses of John Chamberlain (b. 1927) combined the abstraction of expressionism with a return to objects drawn from the real world.

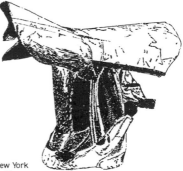

John Chamberlain
Untitled 1963, 1963
Steel automobile parts, h. 31"
Collection, Whitney Museum of American Art, New York
Purchase, with funds from the Howard and Jean Lipman
 Foundation, Inc., and gift

46 Kinetic Constructivism

Constructivism, a doctrine formulated in Russia by the Pevsner brothers (Antoine Pevsner and Naum Gabo, who dropped his last name to avoid confusion with his brother), rivaled Cubism as the most significant influence on 20th-century abstract art. For sculpture, Constructivism was a more compelling force than Cubism. It promoted four ideas. (1) Reality must be interpreted through the representation of time and space. (2) Volume and mass are not sufficient interpreters of reality. (3) Art must be dynamic and not static. (4) New materials and processes must be used to express the new century.

The 1920 Realist Manifesto issued in Moscow and the example of Gabo's sculptures in Europe in succeeding years engendered a new approach, one that incorporated space and time into the sculptural object. The previous preoccupation with mass, volume and representational form gave way to open forms incorporating space as an integral part of the work. The openness of form encouraged a viewing of the sculpture from all four sides, thereby integrating the elements of time and movement into the work.

Naum Gabo
Translucent Variation of Spheric Theme,
1951 version of 1937 original
Plastic, h. 22⅜"
The Solomon R. Guggenheim Museum, New York

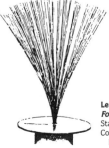

LOOK FOR:

Sculpture perceived sequentially
Wind- or motor- or solar-driven movement
Thin elegant lines
Abstract, non-referential objects
Open, space-defining sculptures
Beauty of materials and shapes

Len Lye
Fountain, 1959
Stainless steel rods, h. 85"
Collection, Whitney Museum of American Art, New York. Gift of the Ford Foundation Purchase Program

Sculpture could no longer be grasped in an instant from a single perspective. The viewer had to walk around the work, taking in the different appearance of each side in sequence.

David Smith's sculptures were among the earliest constructivist sculptures in the United States to require perambulation for full comprehension. Alexander Calder's mobiles of the 1930s introduced the idea of movement to the sculpture itself. José de Rivera (1904–1985) used a motor to rotate his sculptures so that the different perspectives could be experienced in a slowly changing fluid continuum. George Rickey (b. 1907) relied on the wind to activate his needle-like constructions. Len Lye's (1901–1980) *Fountain* shows the artist's interest in representing motion rather than defining an object.

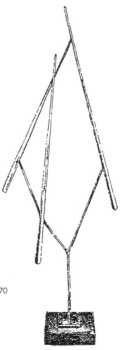

George Rickey
Three Fixed Lines and Three Moving Lines, 1970
Steel, h. 94"
Cincinnati Art Museum, Ohio. Gift of Mr. and
Mrs. John W. Becker

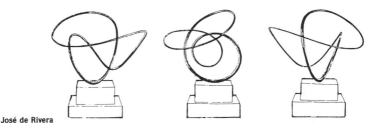

José de Rivera
Construction #119, 1970
Stainless steel, w. 29"
Collection, FirsTier Bank, Lincoln, Nebraska

Claes Oldenburg
Three-Way Plug, Scale A (Soft) Prototype in Blue, 1971
Naugahyde, wood, chain, plastic, and wire, h. 144"
Coffin Fine Arts Trust Fund, 1972. Nathan Emory Coffin Collection of the Des Moines Art Center, Iowa

Pop Art emerged in the 1950s as a specifically American reaction to the predominance of abstract art. Pop Art insisted upon a return to the American scene and to recognizable subject matter.

Pop Art took its images from billboards, comic strips, movies, television, newspapers and magazines. It was cool and detached. It drew its reality from the illusory world of advertising and the mass media.

Pop Art sculpture took several different forms. In *Brillo,* Andy Warhol (1925–1988) explored one of his painted themes in three dimensions. Robert Rauschenberg (b. 1925) and Jasper Johns (b. 1930) attached objects to their canvases, challenging the concept of a painting as solely a two-dimensional surface. "Painting relates to both art and life," Rauschenberg said. "Neither can be made. I try to act in the gap between the two."

Rauschenberg's "combines" blurred the boundaries between

LOOK FOR:

Imagery drawn from popular culture
Surprising scale and use of materials
The familiar given new meaning
"Combines" (combinations of found objects and painted surfaces)
Trompe l'oeil (fool-the-eye) sculptures

Andy Warhol
Brillo, 1964
Silk-screened wood, h. 17"
Private collection
Copyright the Estate and Foundation of Andy Warhol, 1989. Courtesy ARS N.Y.

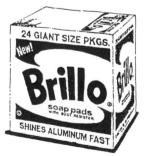

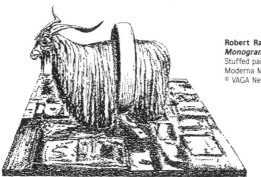

Robert Rauschenberg
Monogram, 1959
Stuffed painted goat. h. 48"
Moderna Museet, Stockholm
© VAGA New York 1989

painting and life and between painting and sculpture. By incorporating a stuffed goat and a tire into his *Monogram,* Rauschenberg, like the Dadaists, expanded the boundaries defining a work of art. The 1961 Museum of Modern Art exhibit and catalog, *The Art of Assemblage,* popularized Rauschenberg's combines.

Johns explored illusion in his *Painted Bronze II,* a *trompe l'oeil* so successful that the beers look ready to drink.

The sculptures of Claes Oldenburg (b. 1929) derive their impact from ironic twists. America's most popular fast food, *Giant Hamburger* (1962), becomes a work of art; a hard object, *Toilet* (1966), is sculpted in soft materials; a small commonplace object, *Three-Way Plug*, becomes a monumental sculpture.

Pop Art is quintessentially American with its specifically American imagery and techniques. The bravado and audacity of the Pop Art sculptors reflected the new status and self-confidence of the United States after World War II.

Jasper Johns tells a story about gallery owner Leo Castelli: *Willem de Kooning said . . . you could give him two beer cans and he could sell them. I heard this and thought, "What a sculpture—two beer cans" . . . so I did them—and Leo sold them.*

Jasper Johns
Painted Bronze, 1964
Painted bronze, h. 5½"
Collection, Dr. Peter Ludwig, West Germany
© 1989 ARS N.Y. / ADAGP

Donald Judd
Untitled, 1984
Aluminum with blue plexiglass over
black plexiglass, h. 177³⁄₁₆"
Collection, Whitney Museum of
American Art, New York. Purchase,
with funds from the Brown
Foundation, Inc. in memory of
Margaret Root Brown

Minimalism evolved in the early 1960s as a direct reaction to the meaning and content inherent in Pop Art and Expressionistic Abstraction. Minimalists sought to divest the sculpture of any meaning outside itself.

Most Minimalist sculptors began their careers as painters. After experimenting with three-dimensional wall constructions, they moved into sculpture. The 1963–64 exhibition of Donald Judd's (b. 1928) painted metal and wood geometric constructions at the Green Gallery in New York introduced the new style.

Minimalist sculptures exemplify the Bauhaus philosophy promoting the union of art and machines to create new forms appropriate to the 20th century. Made of common commercially manufactured materials, these works reveal nothing of the sculptor's hand. Minimalist constructions, such as Carl Andre's (b. 1935) *Lever,* are devoid of focal point or accent. They often comprise repeated parts of a mathematical series. They refer to nothing beyond themselves and represent only the essence of their "object-hood." According to Robert Morris (b. 1931), the most important aspect

LOOK FOR:

Non-referential, static forms
A self-contained whole forming a gestalt
Purity of abstract geometric forms
Repeated modules in non-hierarchical relationships
Commercially manufactured parts

Larry Bell
Terminal Series, 1968
Glass and chrome, h. 12¼"
Modern Art Museum of Fort Worth, Texas. Museum
purchase, the Benjamin J. Tillar Memorial Trust

of a Minimalist sculpture is "the apprehension of the gestalt."

Sol LeWitt (b. 1929) stressed that the significance of Minimalism was its conceptual content rather than its perceptual appearance. "Conceptual art is made to engage the mind rather than the eye or emotions," he said. "It is the objective of the artist who is concerned with conceptual art to make his work mentally interesting to the spectator, and therefore usually he would want it to become emotionally dry."

Minimalist sculptures are literal, austere and controlled. They are often distilled geometric forms, abstracted and reduced to the concept of roundness or squareness. They may hang from walls, be placed directly on the ground or floor without base or pedestal, or fill a space using its walls as boundaries.

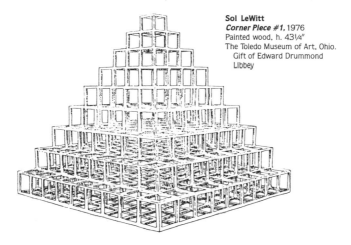

Sol LeWitt
Corner Piece #1, 1976
Painted wood, h. 43¼"
The Toledo Museum of Art, Ohio.
Gift of Edward Drummond
Libbey

Simplicity of shape does not necessarily equate with simplicity of experience. Unitary forms do not reduce relationships. They order them.

—Robert Morris

Carl Andre
Lever, 1966
Firebricks, 29' long
National Gallery of Canada, Ottawa
© VAGA New York 1989

Inherent in Minimalism was Duchamp's concept of the ready-made. Minimalist sculptors used commercially made objects for their work; they selected the objects and arranged them. This way of working led Robert Morris to the idea that the process of creating art was more significant than the finished piece. In fact, Morris rearranges many of his sculptures, particularly the felt pieces, each time they are displayed.

Process Art developed as the activity of sculpture rather than the form of sculpture. The philosophy of Existentialism was the underpinning of Process sculpture: in actions, humans discover their essence.

Eva Hesse (1936–1970) and Richard Serra (b. 1939) took part in the Process movement when they transformed raw materials through a refining process. Hesse melted, rolled and molded forms. Serra used molten lead that he handled while hot and liquid. The final form of these works attests to the process that made them.

Other works of Process Art involve the viewer in their completion. Walter De Maria's (b. 1935) *Boxes for Meaningless Work* includes an inscribed instruction: "Move pieces back and forth." De Maria sees the artist's role as that of a catalyst involving the viewer in active participation in the creative process.

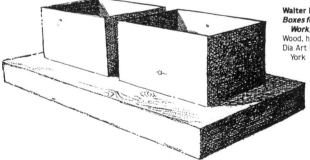

Walter De Maria
Boxes for Meaningless Work, 1961
Wood, h. 24"
Dia Art Foundation, New York

LOOK FOR:

Works that reveal the way they were made
Pieces that involve viewer participation

Eva Hesse
Sans II, 1968
Fiberglass, h. 38"
Collection, Whitney Museum of American Art, New York. Purchase, with funds from Ethelyn and Lester J. Honig and the Albert A. List Family

Conceptual Art grew out of Minimalism. Artist Sol LeWitt described the rationale for this form: "The idea itself, even if not made visual, is as much a work of art as any finished product." Unrestricted by the practicalities of giving material form to their ideas, artists could conceive bold and impossible works. Robert Smithson (1938–73) and Walter De Maria conceptualized projects so vast or so expensive that they were not likely to be accomplished.

De Maria described a 1961 Conceptual Art project this way: "I have been thinking about an art yard I would like to build. It would be sort of a big hole in the ground. Actually, it wouldn't be a hole to begin with. That would have to be dug. The digging of the hole would be part of the art. Luxurious stands would be made for the art lovers and spectators to sit in."

Smithson also conceived of outdoor projects on a grand scale. To exhibit his Conceptual Art projects during the 1960s, he collected rocks from proposed sites, placed them in containers and put them on display in galleries. He labeled them "Non-Site" pieces, indicating their state of being divorced from their natural site.

The freedom of thought exercised by Conceptual artists was a catalyst for the creation of Earthworks. Christo's (b. 1935) *Running Fence* (1972–76),

extending for 24.5 miles across the California countryside, exemplifies the surprising realization of a Conceptual Art project. Occasionally, the seemingly impossible was accomplished after being conceived, discussed and drawn.

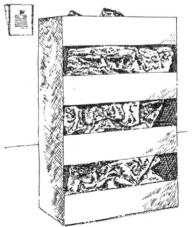

LOOK FOR:

Written descriptions, drawings, and models of proposed large-scale projects

Robert Smithson
Non-Site (Palisades-Edgewater, N.J.), 1968
Painted aluminum, enamel, and stone. h. 56"
Map and Description (site), 1968
Ink on paper, map h. 1½"; description h. 7⅜"
Collection, Whitney Museum of American Art, New York.
Purchase, with funds from the Howard and Jean
Lipman Foundation, Inc.

The work of Isamu Noguchi foreshadowed the Environmental Art movement that began in the late 1960s and continues to attract adherents today. In the early 1930s, his proposed design for a children's park, *Play Mountain,* expressed his search for "a larger, more fundamentally sculptural purpose for sculpture, a more direct expression of Man's relation to the earth and to his environment."

Environmental Art has roots in Minimalism and Conceptual Art. Robert Morris's *Labyrinth* combines purity of form with the viewer's experience of walking through a Minimalist environment. Carl Andre moved from Minimalist works like *Lever,* a row of firebricks displayed in a gallery, to the Environmentalist *Log Piece* (1968), a 100-foot span of logs resembling a path in Aspen, Colorado.

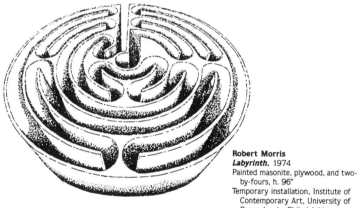

Robert Morris
Labyrinth, 1974
Painted masonite, plywood, and two-
 by-fours, h. 96"
Temporary installation, Institute of
 Contemporary Art, University of
 Pennsylvania, Philadelphia
© VAGA New York 1989

LOOK FOR:

Use of nature's own materials
Use of industrial materials to
 define the landscape
Creation of environments
Design of parks or plazas
 incorporating sculpture
Integration of landscape design,
 architecture, and sculpture

Isamu Noguchi
Landscape of Time, 1975
Granite, max. h. 8'
Federal Building, Seattle

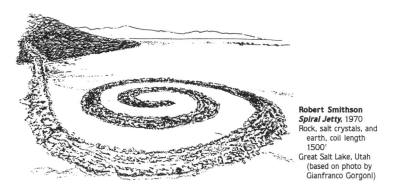

Robert Smithson
Spiral Jetty, 1970
Rock, salt crystals, and
earth, coil length
1500'
Great Salt Lake, Utah
(based on photo by
Gianfranco Gorgoni)

Environmental Art comprises two major directions. The first, known as Earthworks, involves the aesthetic shaping of the natural environment itself, often in remote areas. The second and more traditional direction is the design of parks and plazas in urban centers.

Some Earthwork artists, like Richard Smithson in *Spiral Jetty*, use nature's own materials to change the shape of the environment. Others, like Michael Heizer (b. 1944), alter the natural landscape with manufactured materials. Heizer's *City, Complex One* is an earth mound framed by concrete bars. Maya Lin's (b. 1959) *Vietnam Veterans Memorial* (1982), Christo's wrap projects and De Maria's *Lightning Field* (1973–76) in New Mexico all involve the artist's introduction of manufactured materials into the natural environment.

Those artists concerned with providing sanctuaries of renewal within congested cities combine sculpture with landscape design and architecture. Nancy Holt's (b. 1938) park in Rosslyn, Virginia, contains sculptural objects in a reshaped landscape. Meg Webster's (b. 1944) *Glen* (1988) in the Minneapolis Sculpture Garden is the artist's most site-specific work and her piece most akin to landscape architecture.

Michael Heizer
City, Complex One, 1972–74
Cement, steel, and earth, 110' long
Central eastern Nevada (based on photo by Gianfranco Gorgoni)

Siah Armajani
Dictionary for Building: The Garden Gate,
1982–83
Painted wood, h. 95"
Collection, Walker Art Center, Minneapolis.
 Purchased with funds from William D. and
 Stanley Gregory and Art Center Acquisition Fund

Traditionally, architectural sculpture was ornament attached to a building for decorative, didactic or symbolic purposes. Postmodern Classicism has revived this function. Ray Kaskey's (b. 1943) *Portlandia* is the symbol of the city of Portland, adorning Michael Graves' Portland Building.

Sculptural commissions for contemporary buildings usually occupy entrance plazas or atriums. Architectural Art today differs from its traditional counterpart in materials and scale. Alexander Calder, Tony Smith (b. 1912), Mark di Suvero and others have designed gargantuan abstract sculptures to accompany the sleek, unadorned, machine-like International Style skyscrapers.

Contemporary Architectural Art is also sculpture that resembles architecture. Nancy Holt, Mary Miss (b. 1944) and Alice Aycock (b. 1946) are commissioned to design pieces for parks and plazas. They often create works having the appearance of a structure but lacking utility. Brower Hatcher's (b. 1942) *Prophecy of the Ancients* invites the viewer to enter and walk through the space defined by the work. The initial promise of shelter, however,

LOOK FOR:

Symbolic figures adorning buildings
Large abstract sculptures accompanying
 contemporary buildings
Skeletal structures lacking utility
Explicit architectural forms
Sculpted architectural models

Brower Hatcher
Prophecy of the Ancients, 1988
Cast stone, stainless steel, bronze,
 mixed medium, h. 202"
Collection, Walker Art Center, Minneapolis.
 Gift of the Lilly Family, 1989

is unfulfilled; no protective skin encloses the structural skeleton.

Siah Armajani's (b. 1939) art is explicitly architectural. His beautifully crafted doors and stairs often lead nowhere, creating an ironic tension that invites appreciation of the object for its own sake. In *Dictionary for Building: The Garden Gate*, Armajani has abstracted architectural form, separating it from its function and celebrating its inherent beauty.

Two Washington, D.C., artists are currently creating small scale architectural sculptures reminiscent of architects' models. Dickson Carroll (b. 1940) sculpts colorful architectural fantasies like *Church*. William Christenberry (b. 1936) creates architectural models of poignant rural Southern structures.

Dickson Carroll
Church, 1981
Polychromed wood, h. 36"
Collection, Sam and Kathryn
Smith, Washington, D.C.

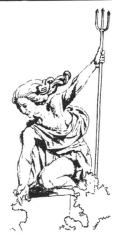

Raymond Kaskey
Portlandia, 1985
Hammered copper, h. 36'
Portland Building, Portland,
Oregon

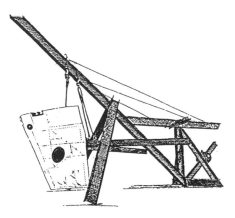

Mark di Suvero
Isis, 1978
Painted steel
Hirshhorn Museum and Sculpture
Garden, Smithsonian Institution,
Washington, D.C. Gift of Institute
of Scrap Iron and Steel, Inc., 1978

From its beginnings, American sculpture has been preoccupied with the human figure. This focus has been nearly constant, except for a brief interlude with European-inspired abstraction after World War II. In the 1950s Pop Art emerged and rekindled the passion for the human form.

George Segal (b. 1924) created a dramatic new form in 1961. His startlingly realistic figures, cast in plaster from live models, were posed in settings from real life. The stark contrast of the white figure against the multi-colored, multi-textured backdrop of a movie theater in *Cinema* evokes the loneliness of the human condition.

California artist Edward Keinholtz (b. 1927) employed realistic plaster body casts to create disturbing tableaux showing the darker side of human nature. He confronted the American public with the issues of racial discrimination, the Vietnam War and the plight of the neglected elderly.

Edward Kienholz
The Wait, 1964–65
Tableau, h. 6'8"
Collection, Whitney Museum
of American Art, New York.
Gift of Howard and Jean
Lipman Foundation, Inc.

LOOK FOR:

Abstracted figures
Startling body casts posed in realistic settings
Social commentary
Incorporation of movement and sound
Symbolic meaning

Marisol
Women and Dog, 1964
Wood, plaster, synthetic polymer and
miscellaneous items, h. 6' 5"
Collection, Whitney Museum of American Art.
Purchase, with funds from the Friends of
the Whitney Museum of American Art

Marisol Escobar (b. 1930) combines abstract blocky forms with painted stylized faces and clothing, creating a surprising colorful juxtaposition. The sculptures are startling and playful, recalling early American folk art.

Sculptors of the 1980s have reasserted the importance of the human figure as icon. Jonathan Borofsky (b. 1942) incorporates movement and sound into his figures. His *Hammering Man* is a powerful, noble giant whose monotonously moving arm suggests that machines have replaced the dignity of manual labor. Joel Shapiro uses blocky beams to suggest a figure in a state of physical or mental tension. Shapiro's *Untitled*, makes explicit David Smith's implicit reference to the human form.

The Hammering Man *is a giant. . . . (He) is also a worker. . . . I tried to make it both male and female. . . . I hope the images are universal or archetypal.*

—Jonathan Borofsky

Jonathan Borofsky
Hammering Man, 1984–85
Painted steel plate and Cor-Ten steel, h. 240″
Collection, Patsy and Raymond Nasher, Dallas, Texas

George Segal
Cinema, 1963
Plaster, illuminated plexiglass, and metal, h. 118″
Albright-Knox Art Gallery, Buffalo, New York. Gift of Seymour H. Knox

Joel Shapiro
Untitled, 1980–81
Bronze, h. 52⅞″
Collection, Whitney Museum of American Art, New York. Purchase, with funds from the Painting and Sculpture Committee

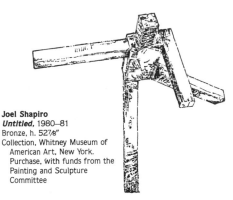

I'm more interested in how one thinks about something than in what something looks like. I am interested in what a house or a figure might mean, . . . but not to illustrate it or describe it.
—Joel Shapiro

Super Realist sculpture and Photo Realist painting were immediately popular when they appeared in the late 1960s. People recognized and understood the subject matter and admired the artists' obvious technical skill.

Duane Hanson (b. 1925) and John De Andrea (b. 1941) simultaneously discovered and independently developed the use of a polyester resin and fiberglass technique for creating incredibly realistic human figures. De Andrea sought to express a lyrical beauty in his sculpted nudes. Hanson initially pursued social commentary. With *Supermarket Shopper,* he began moving toward witty satire aimed at Americans and their habits. He used real hair and clothing to capture the essence of various societal types. By placing his figures in real-life settings, he created *trompe l'oeil* genre scenes. Nancy Graves' (b. 1940) Super Realist *Camel VI* represents an early phase in her career.

The current popularity of realistic bronze sculptures in public places and the selection of Frederick Hart's realistic sculpture of three soldiers to accompany the Minimalist *Vietnam Veterans Memorial* attest to the positive response Americans have toward art they can recognize.

Nancy Graves
Camel VI, 1968–69
Wood, steel, burlap, polyurethane, animal skin, wax, oil, and paint, h. 90″
The National Gallery of Canada, Ottawa
© VAGA New York 1989

LOOK FOR:

Trompe l'oeil genre scenes
Humor and social satire
Tabletop ceramic sculptures
Polyester resin and fiberglass
Ultra-realistic bronze sculptures
 in public places

John De Andrea
Manet: Dejeuner l'Herbe, 1982
Mixed media, lifesize
J.B. Speed Museum, Louisville, Kentucky. Courtesy Carlo Lamagna Gallery, New York

In ceramic sculpture, a parallel tradition of Super Realism has developed. Ceramic pieces by Robert Arneson (b. 1930), Richard Shaw (b. 1941) and Wendy Bolton Rowland (b. 1943) lack the startling *trompe l'oeil* effect because of their smaller scale and exaggerated caricature. These humorous tabletop sculptures captivate the public the way that John Rogers' small plaster genre sculptures once did.

Realism has been the most persistent theme in American art. Even artists who fled to Europe for instruction, inspiration and freedom tempered their work with realism once they returned home.

Duane Hanson
Supermarket Shopper, 1970
Fiberglass, polychromed in oil, with accessories,
 lifesize
Neue Galerie-Sammlung Ludwig, Aachen
Courtesy O.K. Harris Works of Art, New York

Robert Arneson
California Man, 1982
Ceramic, h. 78"
San Francisco Museum of Modern Art.
 Gift of the Modern Art Council

Richard Shaw
House of Cards #3, 1979
Porcelain with overglaze transfers,
 h. 19½"
Oakland Art Museum, California

In the 1980s much of contemporary sculpture continued to be concerned with content and focused upon references to the real world. A common theme has been the transformation of the recognizable object into something beyond itself—its beauty or sense of design is heightened, its expressionistic quality is accentuated or perhaps an ironic note is sounded. Rarely is the functional usage of the object retained. It is not a sculpture of narrative or social commentary. The sculpture, rather than being abstract, has content because of the recognizable objects incorporated within it which are so transformed that the sculpture is apprehended as a totally new object. These metamorphosed sculptures are cerebral and tactile, inspiring the viewer to think, philosophize and touch the work of art.

Nancy Graves, always an independent artist, exemplifies this category of Metamorphoses. Using a technique of direct casting from objects, she incorporates the most mundane of found objects into her sculptures and transforms them in bursts of color. Close inspection of her work reveals a sardine or a banana transformed into a colorful structural element in a large-scale drawing-in-space sculpture. Graves works intuitively, like David Smith, as she fuses her bronze-cast objects and then applies patinated color.

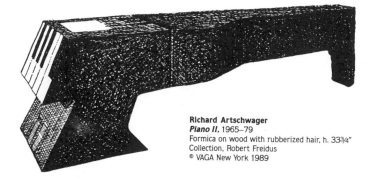

Richard Artschwager
Piano II, 1965–79
Formica on wood with rubberized hair, h. 33¾"
Collection, Robert Freidus
© VAGA New York 1989

LOOK FOR:

Found objects or casts of them
Tactile qualities
Thought-provoking arrangements
Contrasting surface textures
Juxtaposition of found and created elements
Uniting of abstract design with representational objects

Richard Artschwager (b. 1924), a former furniture maker, combines the craftsmanship of his previous profession with an abstract quality. *Piano II* transforms a musical instrument into a surprising art object. The beauty of the sleek keyboard and foot pedals abstractly accentuated in formica contrasts with the rubberized hair covering the body of the instrument.

Jackie Winsor (b. 1941) in *#1 Rope* has used rope twined like a ball of knitting yarn. She stacked the balls on pieces of wood resembling knitting needles. This motif is repeated like a Minimalist module to create the overall effect of texture within a bounded form.

In 1983, Meg Webster sculpted *Two Hills for Passage*, which consisted of two packed grassy earth mounds set inside a gallery. Presenting the grass out of context heightened the viewers'

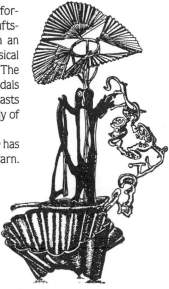

Nancy Graves
Relocomorph, 1981
Bronze with polychrome patina, h. 58"
Collection, Phyllis A. Katz
© VAGA New York 1989

awareness of the earthwork and of the process of growth. The appearance of the mounds was transformed as the grass grew under artificial light.

Donald Lipski (b. 1947), Robert Lobe (b. 1945) and Walter Martin (b. 1953) are currently exploring metamorphoses in individualistic ways.

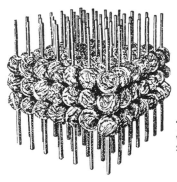

Jackie Winsor
#1 Rope, 1976
Wood and hemp, h. 42"
San Francisco Museum of Modern Art. Purchased with the aid of funds from the National Endowment for the Arts and the New Future Fund

As the 1990s begin, a new direction is evident. American sculptors continue to pursue the identified current trends, but in many cases their work cannot be rigidly confined to one stylistic category. Environmental art has evolved into landscape art with works by Meg Webster and Mary Miss. Architectural art has gained considerable recognition through site-specific structures by Siah Armajani. The mirrored glass houses of Lucas Samaras (b. 1936) are architectural and metamorphic. Furniture art has become a new focus with Scott Burton (1939–1989), Richard Artschwager and Robert Gober (b. 1954), but their sculptures are also metamorphoses. Stylistic boundaries have blurred.

Figural art continues to be a major theme with popular appeal, but Joel Shapiro's incorporation of both abstract and figural reference reveals his exploration of several directions simultaneously. Judith Shea's (b. 1948) training as a clothing designer has led to her fascination with the use of vacant clothing casts to symbolize a human presence. In *Without Words,* she combines a facial fragment, a headless figure and a vacant overcoat to make reference to Classical sculpture while exploring humanity's existential loneliness.

Underlying sculpture of the 1980s is Abstraction which never became a clear category in American sculpture but has been a potent latent presence since the first decade of the 20th century. The American people in their deep-seated longing for attachment to the real world through their art have struggled against abstract art emanating from Europe. In the 1980s some American sculptors like Martin Puryear (b. 1941) and Jene Highstein (b. 1942) pursued abstract sculptural forms, but the dominant theme of the decade has been connection to the real world. Americans like the concrete, the tangible, the literal. The artist who abandons the real world for any length of time loses contact with the American public.

LOOK FOR:

Blurring of stylistic boundaries
Historical references
Latent abstraction
Layers of meaning
Individualistic pursuits

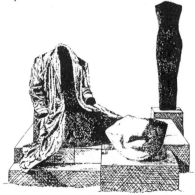

Judith Shea
Without Words, 1988
Bronze, cast marble, limestone, h. 78"
Collection, Walker Art Center, Minneapolis.
 Gift of Jeanne and Richard Levitt, 1988

Claes Oldenburg and Coosje van Bruggen
Spoonbridge and Cherry, 1987–88
Aluminum, stainless steel, and paint, l. 51½′
Collection, Walker Art Center, Minneapolis. Gift of Frederick R. Weisman
in honor of his parents, William and Mary Weisman, 1988

Spoonbridge and Cherry, a monumental *trompe l'oeil,* illustrates the pluralism of contemporary trends in American sculpture as the 20th century draws to a close. This work, by Claes Oldenburg and Coosje van Bruggen (b. 1942), cannot be contained within a single stylistic category. It is a fine example of contemporary sculpture's Synthesis Within Pluralism.

First of all, *Spoonbridge and Cherry* exemplifies Metamorphosis, wherein small objects "writ large" become monumental and compelling. The work can also be considered Super Realism because the spoon and the cherry are clearly identifiable, even at a distance. The sculpture falls into the category of Environmental Art because it is an integral part of the landscape design for the sculpture garden. It is Architectural Art because of its implied function as a bridge: the spoon's handle spans the pond to reach the cherry, which is also a fountain. Finally, there is an abstract quality about *Spoonbridge and Cherry.* The artists have abstracted pure geometric shapes from the real objects. The roundness of the cherry, the ovalness of the bowl of the spoon and the arc of the handle are beautiful abstract shapes in themselves. This one work embodies most of the contemporary American sculptural themes.

The continuing dominance of realism and the latent influence of abstraction are both expressed in *Spoonbridge and Cherry.* While the American public remains fixated on the real world, American sculptors have successfully fused abstraction with realism. They have created an art that is uniquely American and thoroughly modern. They have achieved the kind of rich synthesis that a pluralistic society makes possible.

In the preparation of the text for *Clues to American Sculpture,* I am indebted to Wayne Craven for his thorough and perceptive study of American sculpture. For many years sculpture has been the most neglected of the fine arts. Until this century it had not reached parity with its sister arts, architecture and painting. Wayne Craven has done much to raise the consciousness of Americans to the interesting history of American sculpture. I would encourage readers to seek out his comprehensive survey *Sculpture in America.*

I would also like to call attention to the book that accompanied the Whitney Museum's Bicentennial Exhibition: *200 Years of American Sculpture.* The rich text and thorough artists' biographies provided an invaluable source and guide in the preparation of *Clues to American Sculpture.*

Finally, I want to make special mention of the Walker Art Center's catalog *Sculpture Inside Outside,* accompanying the 1988 exhibit of the same name. The book presents a convincing analysis of current trends in contemporary sculpture.

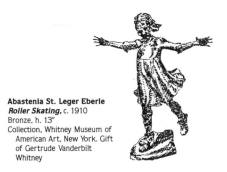

Abastenia St. Leger Eberle
Roller Skating, c. 1910
Bronze, h. 13″
Collection, Whitney Museum of
American Art, New York. Gift
of Gertrude Vanderbilt
Whitney

Ashton, Dore (editor). *Twentieth-Century Artists on Art.* New York: Pantheon Books, 1985.

Beardsley, John. *Earthworks and Beyond: Contemporary Art in the Landscape.* New York: Abbeville Press, 1989.

Craven, Wayne. *Sculpture in America.* Newark: University of Delaware Press, 1984.

Elsen, Albert E. *Origins of Modern Sculpture: Pioneers and Premises.* New York: George Braziller, 1974.

Hunter, Sam, and John Jacobus. *American Art of the 20th Century*. New York: Harry N. Abrams, 1973.

Krauss, Rosalind E. *Passages in Modern Sculpture*. Cambridge: MIT Press, 1981.

Lucie-Smith, Edward. *Sculpture Since 1945*. New York: Universe Books, 1987.

Nash, Steven A. (editor) *A Century of Modern Sculpture: The Patsy and Raymond Nasher Collection*. New York: Rizzoli, 1987.

Rose, Barbara (editor). *Readings in American Art, 1900–1975*. New York: Praeger, 1975.

Walker Art Center. *Sculpture Inside Outside*. New York: Rizzoli, 1988.

Whitney Museum of Art. *200 Years of American Sculpture*. New York: David R. Godine, 1976.

Additional resource: the International Sculpture Center, 1050 Potomac St. N.W., Washington, D.C. 20007 (telephone 202-965-6066). The Center holds conferences and publishes *Sculpture,* a bimonthly magazine.

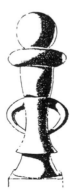

Isamu Noguchi
The Queen, 1931
Terra-cotta, h. 45½"
Collection, Whitney Museum
 of American Art, New York.
Gift of the artist

A selection of outdoor sculpture collections to visit:

CALIFORNIA
Oakland Museum Sculpture Garden
Franklin D. Murphy Sculpture Garden, University of California at Los Angeles, Frederick S. Wight Art Gallery
Mary S. Marcy Sculpture Court and Garden, San Diego Museum of Art, Balboa Park
Norton Simon Sculpture Garden, Norton Simon Museum, Pasadena

CONNECTICUT
Aldrich Museum of Contemporary Art, Ridgefield

DISTRICT OF COLUMBIA
Hirshhorn Museum and Sculpture Garden

KANSAS
The E.F. Pierson Sculpture Garden, Nelson-Atkins Museum of Art, Kansas City
Edwin A. Ulrich Museum of Art, Wichita State University

MARYLAND
Wurtzburger and Levi Sculpture Gardens, Baltimore Museum of Art

MASSACHUSETTS
Chesterwood, Stockbridge
Decordova and Dana Museum and Park, Lincoln

MICHIGAN
Cranbrook Academy of Art, Bloomfield Hills

MINNESOTA
Minneapolis Sculpture Garden, adjacent to the Walker Art Center

MISSOURI
Laumeier Sculpture Park, St. Louis
Blanke Sculpture Terrace, St. Louis Art Museum, Forest Park

NEW HAMPSHIRE
Saint-Gaudens National Historic Site, Cornish

NEW JERSEY
John B. Putnam Jr. Memorial Collection, The Art Museum, Princeton University
Newark Museum Sculpture Garden

NEW YORK

Storm King Center, Mountainville

Abby Aldrich Rockefeller Sculpture Garden, Museum of Modern Art, New York

Iris B. Gerald Cantor Sculpture Garden, Metropolitan Museum of Art, New York

Whitney Museum of American Art at Philip Morris, New York

Freida Schiff Warburg Sculpture Garden, The Brooklyn Museum

Wave Hill, Bronx

Nassau County Museum of Fine Arts, Roslyn

Pepsico Sculpture Gardens, Purchase

The Noguchi Garden Museum, Long Island City

Socrates Sculpture Park, Long Island City

Artpark, Lewiston

OHIO

Columbus Museum of Art Sculpture Park

OREGON

Evan H. Roberts Memorial Sculpture Garden, Portland Art Museum

PENNSYLVANIA

University of Pennsylvania, Philadelphia

Morris Arboretum, University of Pennsylvania, Philadelphia

The Carnegie Sculpture Court, Pittsburgh

SOUTH CAROLINA

Brookgreen Gardens, Murrells Inlet

TEXAS

Dallas Museum and Sculpture Garden

The Meadows Museum, Southern Methodist University, Dallas

Lillie and Hugh Roy Cullen Sculpture Garden, Museum of Fine Arts, Houston

VIRGINIA

Virginia Museum of Fine Arts, Richmond